RENOIR
NUDES

Translated by David Radzinowicz Howell

First published in the United States of America in 1996
by UNIVERSE PUBLISHING
A Division of Rizzoli International Publications, Inc.
300 Park Avenue South
New York, NY 10010

and THE VENDOME PRESS

Front cover image: *Reclining Nude*, 1897. Oil on canvas.
Winterthur, Oskar Reinhart Collection. © Photo AKG, Paris.

Back cover image: *Reclining Nude Seen from the Back* or
Rest after the Bath, c. 1909. Oil on canvas. Paris, Musée d'Orsay,
gift of Dr. and Madame Albert Charpentier. © Photo R.M.N.

ISBN 0-7893-0062-1

Printed and bound in Italy

Library of Congress Catalog Card Number: 96-60679

UNIVERSE OF ART

RENOIR NUDES

TEXT BY ISABELLE CAHN

UNIVERSE/VENDOME

The Painter of Women

enoir adored women. Throughout his life he painted hundreds of them nude. Far from being a champion of feminism, Renoir extolled the "natural" woman who looked after the house and her children and who found pleasure in domestic chores. His views about a woman's place were conservative yet representative of a large majority of nineteenth-century French society. His images must be seen within this context, wherein a strict separation of public spheres equated men with culture and women with nature. Just when women were contesting their position in society, paintings appeared that fuse the body with nature, and that offer a retreat to Arcadia, with nostalgic overtones. In their re-naturalization of the modern woman, Renoir's nudes represent an homage to this idealized, mythic vision.

One of seven children (his father was a tailor and his mother a dressmaker), Renoir tried to re-create in his own home the vivacious, warm atmosphere he had known as a child. All the women in his life, from Aline Charigot to his maids, models, and neighbors, lived together in joyful disorder in the Chateau des Brouillards on the slopes of the then pastoral Montmartre. "Our house was full of women," Renoir's son, Jean, recounts in his biography *Renoir, My Father* (1962). "The tables strewn with odds and ends for sewing and dressmaking." In the company of women, Renoir was said to have blossomed, mentally and physically. He claimed that male voices

tired him, but those of women left him rested; he would ask his maids to sing, laugh and make noise as he worked because a "feminine" ambiance gave him happiness and inspiration.

Despite his love of women, Renoir did not have a reputation for promiscuity. Among his first documented lady friends was Berthe, "a superbly healthy blonde, one of those girls with unruly hair who spend their time putting their chignon in order." After that came a brunette, Lise Trehot, his favorite model between 1865 and 1872, and about ten years later, Aline Charigot, the most important woman in his life. Renoir preferred to paint these models as if they were flowers, or manifestations of nature, posed in bright, gaily colored landscapes on the seashore or riverbank. Women were his pretext for painting, and the medium into which he channeled all his passionate energy as an artist. Whereas Gauguin celebrates the "primitive" woman, and Degas the modern woman, Renoir, in the tradition of the great Fragonard, Boucher and Watteau, celebrates the mythical woman of Arcadia.

Renoir and His Models

While Renoir could not do without models, he did not demand lengthy sittings in unmoving poses. On the contrary, he preferred his models to be unpoised, to be "natural," to express their personal temperaments. By emphasizing the more modern, rhetorical poses of everyday life, Renoir could free himself from the codes of artistic convention. Jean Renoir recalls that throughout his father's career "he continued to

'caress and stroke the motif' [of the nude woman], the way one caresses and strokes a woman so that she can fully express her love." For the painter, the model's body was but a pretext. "I can't do without a model," Renoir told his biographer, Georges Rivière, "but one has to know how to forget the body too, otherwise one's work gives off a physical odor." Finding a model was not always easy. Renoir walked up and down the Montmartre hills in an often vain search. In general, Renoir preferred as models robust Rubensesque women with triangular faces, snub noses, almond-shaped eyes and wide, red mouths. These "cat women," as he called them, he generally found in the suburbs of Paris.

among these women was Nini, who sat for the painter between 1874 and 1880. Her small face and blonde hair can be seen in a number of paintings dating from the period of Renoir's *Moulin de la Galette* painting (1876). After 1900 the artist generally chose his models from among his family or close friends. One of his later sitters was Gabrielle Renard, a young cousin of his wife, originally from Essoyes, who looked after their son, Jean. Her good looks and sculptural body aroused the jealousy of Mme Renoir, who threw her out of the house to prevent further sittings. In his late years, his favorite model was a woman we know as La Boulangère, the baker's wife. She sat for Renoir and he painted her as she busied herself around his house with the household activities of sewing and knitting. Because he enjoyed having this sort of informal relationship with his models, Renoir would generously open his house to them, and in return received both their energy and *joie de vivre*, a pleasant remedy for the suffering he endured from his acute

rheumatism. He would call these young girls nitwits, fat-heads or geese, and threaten them with his cane. They would shriek with laughter, take refuge under the sofa or else run about playing hide and seek, cruelly referring to his now crippled legs. Clearly Renoir insisted on maintaining in his models the playful, "girlish" innocence and coquettishness that he so adored. His paintings equate women with innocence, beauty, and pleasure – a vision far removed from intellectualism. His friend, the poet Mallarmé, made a playful allusion to this in a letter addressed to "Villa des Arts/Near avenue de Clichy/Works Monsieur Renoir/Who, before some naked shoulder,/Grinds no black paint, nor dark thoughts."

Nymphs and Bathers

renoir's earliest nudes represent mythological figures. He probably acquired a taste for antiquity from his years (1861-1863) as an apprentice to the academic painter Charles Gleyre. It was at Gleyre's private atelier that Renoir received a grounding in academic model study. It was also here that he met Monet, Sisley, and Bazille – thereby forming the artistic bonds that would eventually lead to the birth of Impressionism. For his first Salon in 1863 Renoir chose to exhibit a *Nymph with a Faun*. However, the jury rejected the painting because of its fleshiness and erotic overtones. Other nymphs, female bathers, and a Diana followed, but all were refused at the Salon. In his nudes from the late 1860s, the women are depicted in the countryside or in a forest setting that corresponded to Renoir's pre-Impressionist landscapes at the time,

such as *Jules Le Coeur in the Forest of Fountainebleau*, of 1866. It was while working in the region of Fountainebleau that Renoir befriended Courbet and, under his influence, began to paint Realist forest scenes and to use the palette knife in a manner similar to Courbet. Renoir would paint his model in his studio and then add in the landscape afterwards *en plein air*. Forever caught between his enthusiasm for the new, anti-academic painting of Manet and Courbet and his desire for Salon acceptance, Renoir's work during this period followed no consistent direction. His style was influenced by both the poetic naturalism of the Barbizon painters, particularly Corot, and by Courbet's Realism. The latter's penchant for buxom women and its subsequent influence on Renoir is most evident in such large nudes as *Diana the Huntress*, (1867), and *Bather with a Dog*, (1870). For a number of years Renoir wavered between representations of mytholo-gical figures and more modern women without historical pretext, or anecdotal referents. His first public success came at the Salon of 1870 with a *Bather with a Dog*. In this painting, Lise Trehot is presented as a monumental nude in sculptural relief. Small, tight brush strokes give a tactile sense of the skin's surface, and demonstrate the direct influence of Monet. But these early nudes have none of the lushness and radiance of the artist's later nudes, and remain closer to Manet and Courbet than to Rubens or Titian.

r enoir's style began to evolve after he befriended Monet and the two painted together at La Grenouillère in 1869. Under Monet's immediate influence, Renoir began to render objects with an emphatic, animated brushwork. The painters participated in an experiment in optical form dissolution of

a kind that was to lead to Impressionism. Upon his return from La Grenouillère, Renoir sought the difficult task of applying this technique to his figural compositions. *The Promenade*, (1870), represents an early attempt.

During 1873 Renoir joined Monet, Pissarro, Cézanne, Degas and Morisot at the Café Guerbois to form an independent association for the purpose of sponsoring jury-free exhibitions, in direct challenge to the official Salon. The first "Impressionist" exhibition of 1874 was met with savage criticism. Spectators flooded to the show not to purchase works but to mock this "new" way of presenting reality. In 1876, at the second Impressionist exhibition, the press attacked Renoir's *Study (Torso of a Woman in the Sun)*, 1875. "A large study of a nude woman – whom it would have been preferable to have draped in a dress – depresses us with its violet hues, like gamy meat. Where did the artist unearth such a dispiriting model?" asked Louis Enault in *Le Constitutional*. But no critic could deter Renoir from this "New Painting," and by now he had abandoned mythological themes and had taken to painting women from the Butte de Montmartre. Renoir no longer felt the need to transform Nini and the others into nymphs and muses, but instead asked them to pose nude in the controlled light of the studio to better capture every nuance of their skin, from soft pink to mother-of-pearl. He now painted with lively, quick-fire brush strokes striving to free form from the constraints of line: color had become a language of its own. While Renoir was painting *The Ball at the Moulin de la Galette*, (1876), he was also undertaking a series of bathers in three-quarter profile seated near the water. For the first time

in Renoir's work, a landscape behind a nude provides a powerful counterpoint, but there is no fusion between figure and environment, since the two were painted at different times.

This two-stage execution process was due to difficulties arising when models posed *en plein air*. When in the controlled light of the studio, form and structure could be studied and recorded; however, in the outdoors, the constantly changing light disrupts and fragments form, or merges it with neighboring shapes. Urged on by the prodding of his Impressionist friends and their lengthy discussions about art at the Café Nouvelle-Athènes, Renoir was determined to reconcile the ephemeral, spontaneous technique of Impressionism (a technique indifferent to plastic form) with the human body. His painting, defended by such admirers of "modernity" as Flaubert's publisher Georges Charpentier, Émile Zola and the art critics, Jules and Edmond de Goncourt, now met with a degree of success, which in turn earned him numerous portrait commissions. He had turned to portraits after the Franco-Prussian war when most artists, including Renoir, were suffering from financial setbacks. But the portrait commissions, while offering an escape from poverty, left him so bogged down with work, that he was left with little time to paint nudes.

I n the late 1870s, after having completed a series of portrait commissions, Renoir underwent an artistic crisis. "I had reached the end of the road with Impressionism," he later confided to his art-dealer and friend, Ambroise Vollard, "and had arrived at a point where I could safely say that I knew neither how to paint nor draw." In an attempt to assuage his doubts, Renoir undertook two journeys, the first, in the spring of 1881, to Algeria; the

second to Italy in the fall of the same year. Examining first-hand the work of the Renaissance masters, Raphael in particular, Renoir complained, in letters to friends, that his fear about his inability to draw had been confirmed and that he realized that his paintings lacked a clear pictorial structure. He vowed to change his style.

On the final stage of his voyage Renoir was accompanied by the young Aline Charigot, whom he had met the previous year. This seamstress from Essoyes agreed to pose for him. Her physique of Rubensesque proportions corresponded perfectly to the artist's "type." Using Aline, he painted *Venus in the Bay of Naples*, (1881). This victorious nude figure, standing out from an acid-toned landscape, heralds a new era in Renoir's art. The landscape is made up entirely of little daubs of paint that meld into each other to form the blurred backdrop characteristic of the artist's mature work. By contrast, the figure is clearly delineated and radiates a pale light. This painting represents Renoir's post-Italy style in its diversion from the tenets of Impressionism. Upon his return from Italy, Renoir became increasingly dissatisfied with Impressionism's interest in fugitive effects, its neglect of structure, and its indifference to permanence.

Women or Goddesses

The Italian Nudes

raphael's *Galatea*, which Renoir had admired in Rome, encouraged him to paint the female body in solid, vigorous form. Once again he took up classicism, while rejecting the watered-down version promoted by such academic painters as

Bouguereau and Cabanel. His nudes of the 1880s are not anatomical studies, but present instead Renoir's emotional stance in regard to the female body. His new, anti-Impressionist style revealed a more disciplined approach to drawing and modeling, a stricter formal treatment, and a smoothness of surface. This meticulous approach is counterbalanced by the hazy masses of hair cascading down the models' alabaster torsos, and by the folds of cloth around their hips.

BATHERS IN THE CHANNEL ISLANDS

In September 1885 the painter went to Jersey and then on to Guernsey, where he stayed a month. "Here," he wrote to his art dealer Paul Durand-Ruel, "people bathe among the rocks which also serve as changing cubicles... nothing could be prettier than this hodgepodge of men and women huddled together on the rocks. One would think one was in a Watteau landscape rather than real life... as in Athens, women are not at all afraid of the men next to them on the neighboring rocks. Nothing is more amusing than walking about among the rocks and stumbling on a few young girls getting ready to bathe. And, though English, they're not particularly put out." The freedom among the Guernsey bathers inspired Renoir to produce a number of compositions that served as the starting point for a renewal of the bathing theme, in which landscape predominates. Once back in Paris, Renoir, going over the studies in his studio, produced canvases with female bathers seated close to the viewer, standing out on a sketchy background. *Bather Arranging her Hair*, (1885), is a fine example. In this painting, the clearly delineated contour and

solidity of the woman's body stands in stark contrast to the purely decorative landscape background. "This Venus Anadyomene," wrote the art critic Julius Meier-Graefe, "does not owe her charms to antique sculpture. Her origin comes over in a manner altogether more believable to our modern ideas. She is really 'woman born of foam.' Renoir brings out shining dots of color from the vivid charm of the atmosphere surrounding her, thus avoiding the immobile loneliness of mere painted plasticity." Meier-Graefe adroitly notes Renoir's movement from mythology to modernity and his ability to achieve a charming monumentality.

LES GRANDES BAIGNEUSES (1887)

renoir's sketches from the Channel Islands inaugurated an important body of work that culminated in a masterpiece, *The Great Bathers*, (1885-1887). In 1885 Renoir embarked on a series of preparatory studies in pencil, red chalk, ink and water-color with a large canvas in mind. He made numerous sketches from life, and studied a relief for a fountain at Versailles by the seventeenth-century artist François Girardon, *Diana Bathing*, which was defined by its meticulously precise contours. Renoir, who had always adored eighteenth-century French art, delighted in François Boucher's images of innocent eroticism in which girls playfully frolic in woodland settings. In Renoir's *Great Bathers*, his earlier sponta-neity has been supplanted by a calculated and mannered arrange-ment. This highly controlled period – which corresponded with changes in his private life such as the birth of his son, Pierre, in

1885 – was followed by a large output of loosely sketched nudes that constitute the apotheosis of his art.

A Mediterranean Arcadia

from the end of the 1890s Renoir regularly spent time in the South of France. His technique softened and young, naked women in landscapes became his primary subject matter. The female body in repose was to him the noblest of subjects and he painted it over and over again with only slight variations. The women in these paintings are either surprised at the bath, posed as the Medici Venus, seated near a body of water, or playing unselfconsciously on a beach. Each painting features the playful, coquettish qualities that Renoir so adored. During this period, he was still occasionally tempted by the allegorical or neoclassical. For example, *The Source* is a large-scale decorative reclining nude, reminiscent of Titian's recumbent Venuses, that was completed at the end of the century for his patron, Paul Gallimard. More often than not, however, Renoir's imagination led him to Arcadian scenes of women in landscape. His art was impossible to pidgeon-hole: "Idealist? Naturalist?" asks Maurice Denis in 1892. "As you like. He has made it his business to translate his own emotions, all of nature, and every dream in his own personal way. It is with the joyousness of his own eyes that he composes these marvelous bouquets of flowers, and of women." The nudes from the 1890s represent Renoir's personal fantasies about a world of "natural" women, devoid of time and specificity.

after 1900 Renoir's work evolved towards a Mediterranean Classicism. In 1898 he went to Cagnes in the South of France for the first time and returned fired with enthusiasm. Henceforth, every year he would spend several of the winter months in this region where, in 1907, he built a house, *Les Collettes*. A large garden now served as his *plein air* studio. His health had taken a turn for the worse, yet nothing of his suffering comes through in his paintings, which instead exude a lyrical, utopian quality. No longer able to stand, he would ask his models to pose reclining, and had a special easel made so he could slide the canvas up and down.

After 1905 the color combinations became more evocative of the Mediterranean. For example, in *The Bathers*, 1818-19, two immense recumbent nudes, orange in flesh, are stretched out on a field of yellow, green, and blue. Likewise, Renoir expressed a renewed interest in monumentality. In 1903, the art critic Camille Mauclair wrote of a Renoir painting:

> *"Like the academic nude, it has no age, no date, no origin, it does not come from Academe, but from a land of wild and primitive dreams...Renoir never saw such streaks of frank sumptuous flesh, he dreamt them. Their wide, almond eyes dart out looks that no thought stays, the eyes of indolent, soft antelopes...His totally unintellectual woman never entreats one to avert the gaze from her unsettling flesh, from her breast or stomach, to search for some glimmer of thought in her face. This contented animal had indeed the face which fits her pink cheeks and a fruit-like mouth, eyes dead to the world, all the signs of a 'gentle beast' blossoming in tropical nature where modesty is unknown as vice and where satisfaction knows no bounds."*

This quote relays Renoir's and Mauclair's desire to return to a mythi-
cal time where women would run around nude, like "gentle beasts,"
frolicking in the woods.

Renoir, the painter of women, delighted in the rotund architecture of
shoulder, breast, hip, and thigh. His paintings represent his private
erotic interests but also his desire to re-naturalize the modern
woman by fusing her body with the landscape. His art is a retreat to
Arcadian nature worship, to a mythical time free from constraints of
modern life.

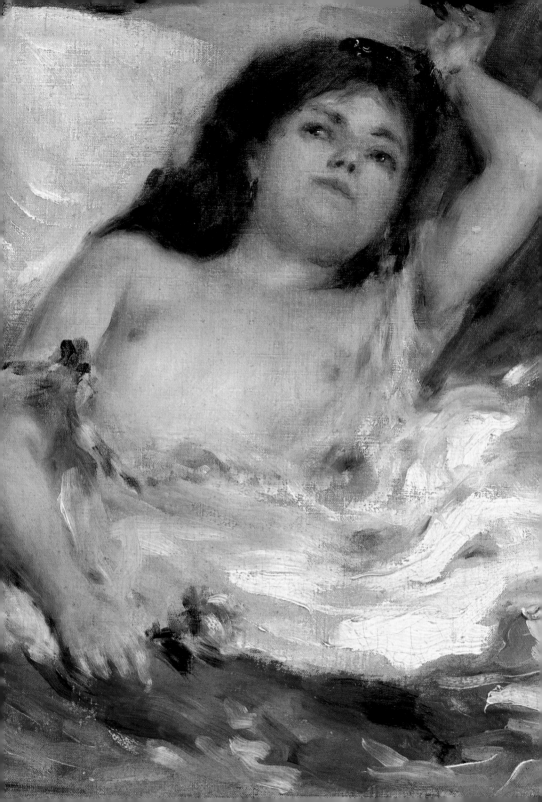

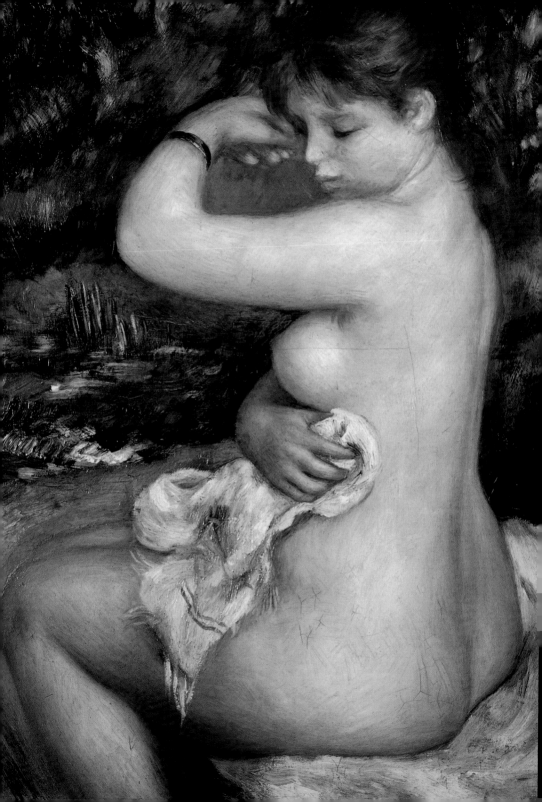

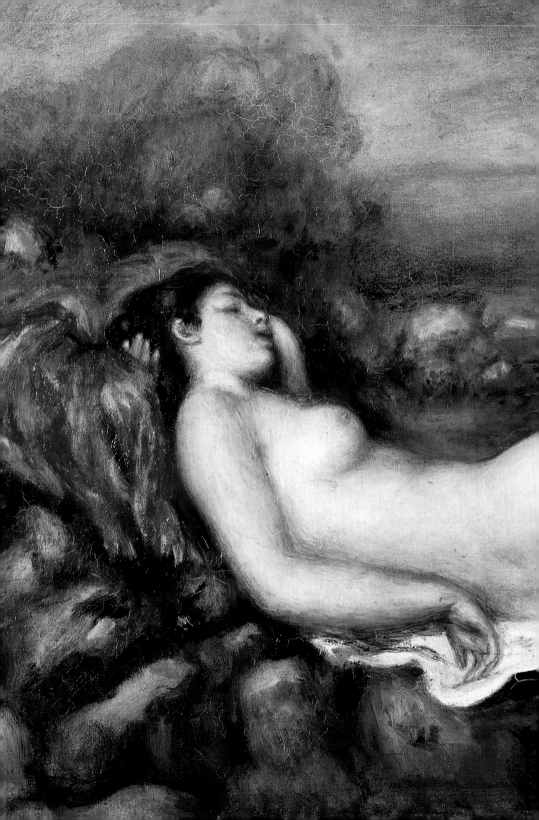

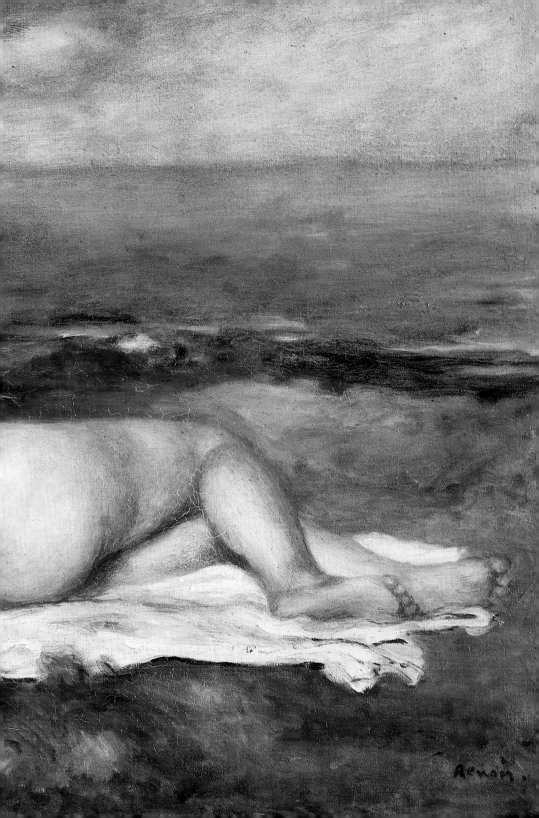

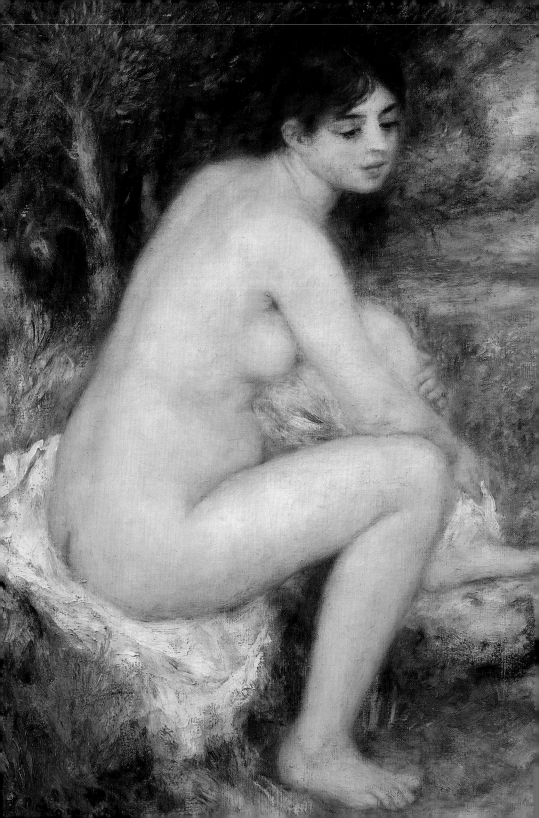

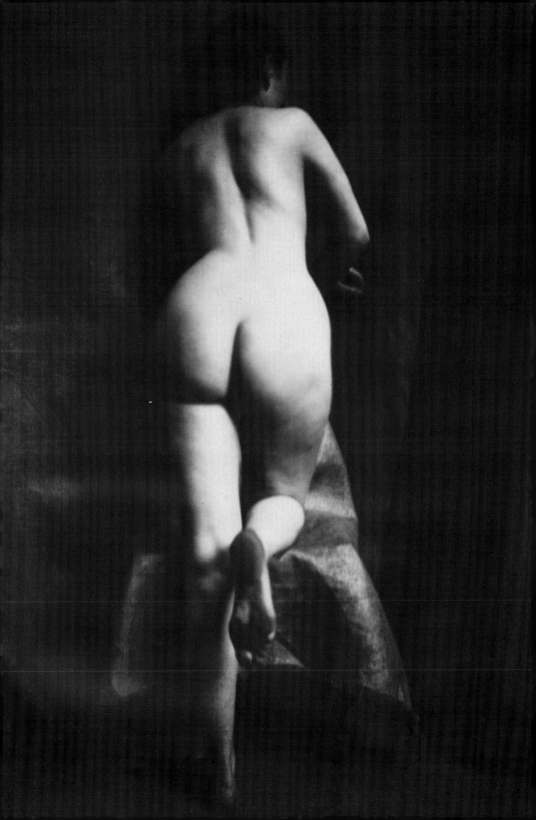

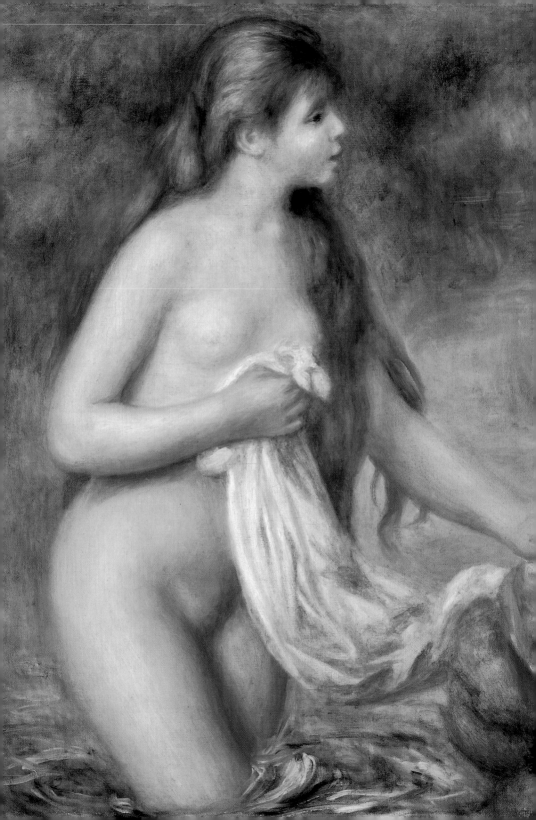

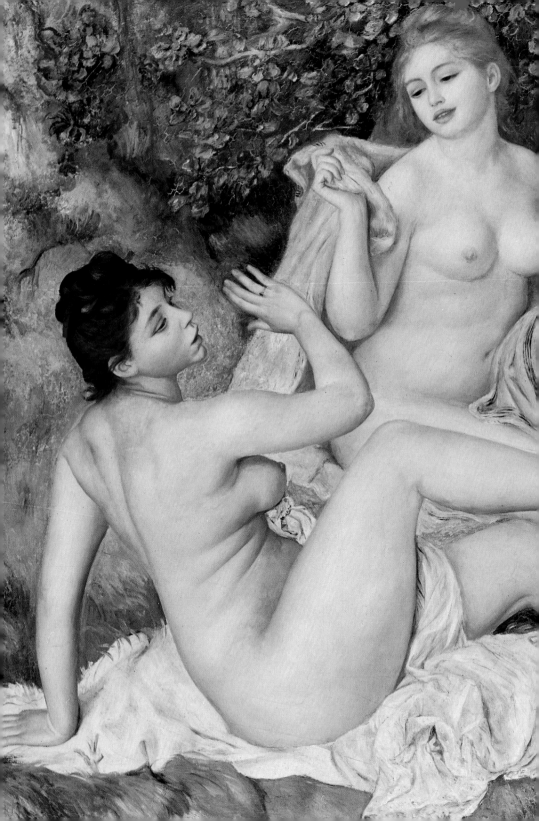

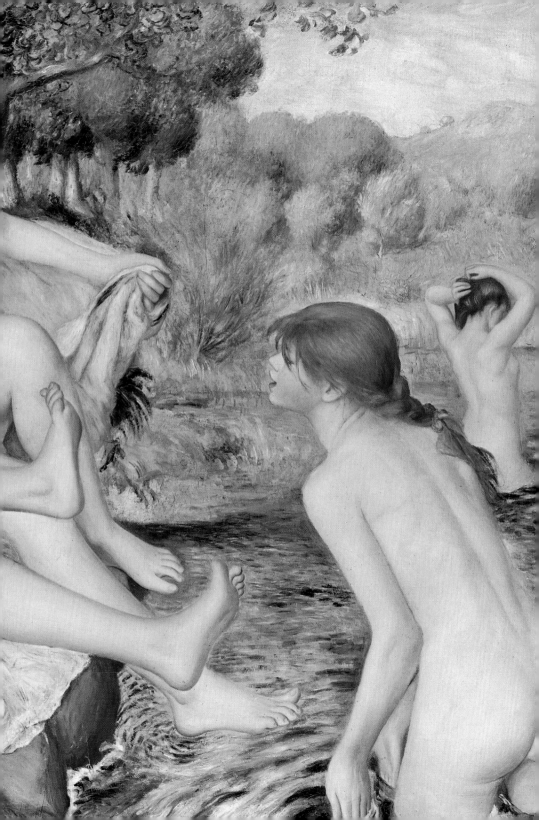

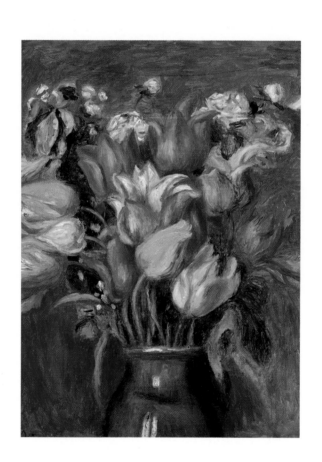

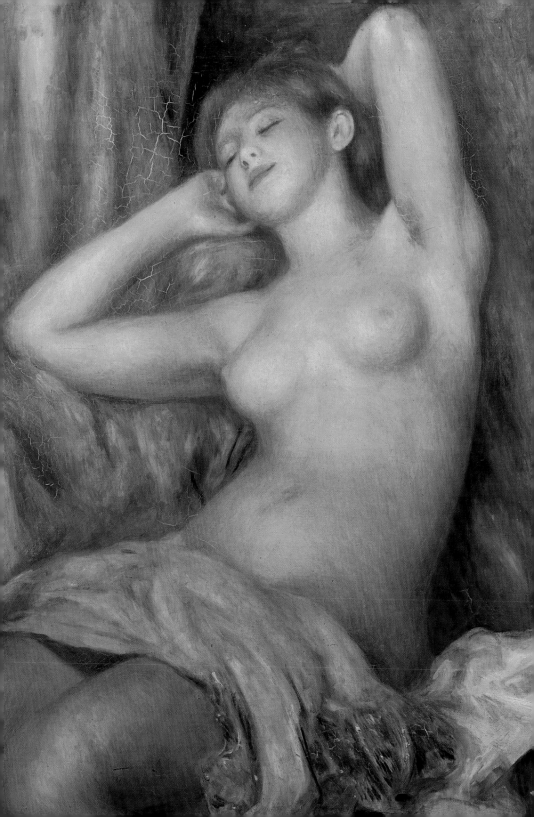

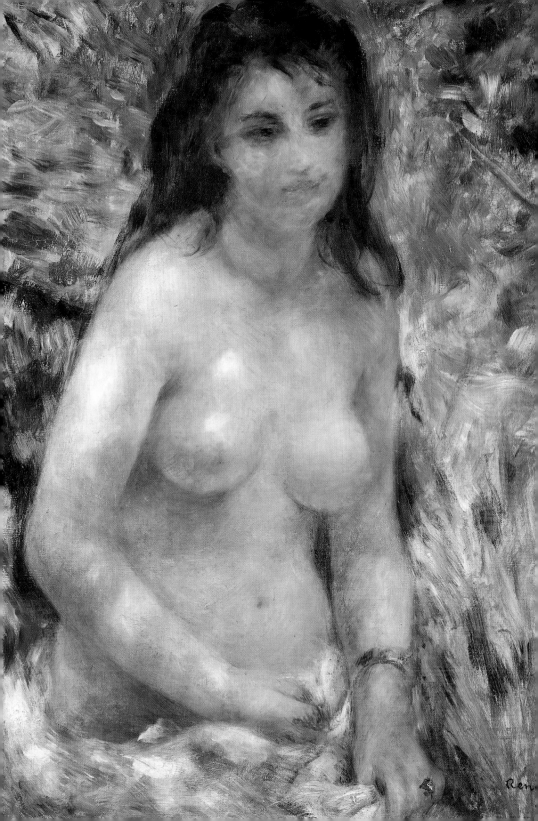

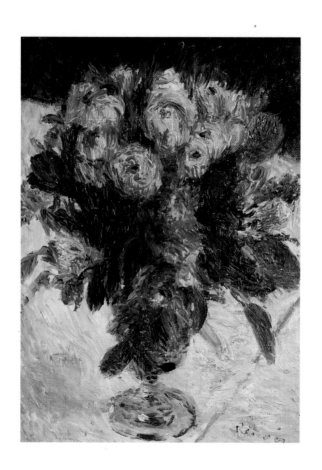

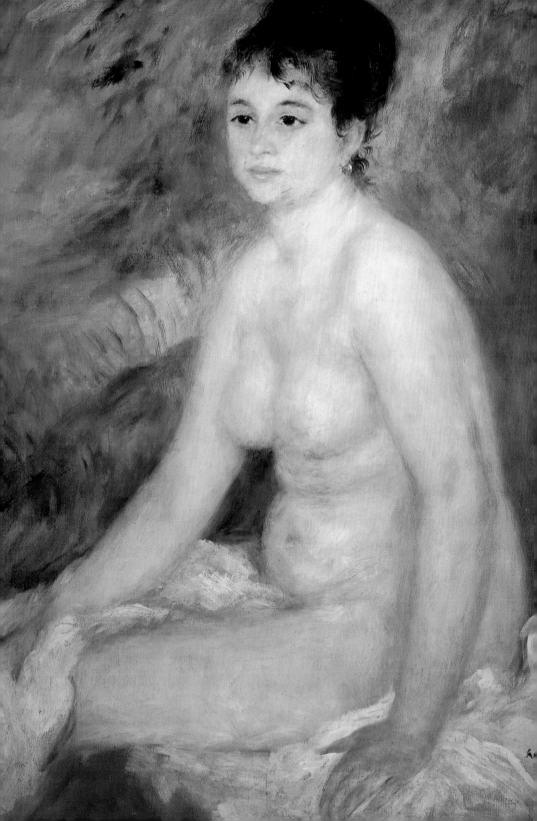

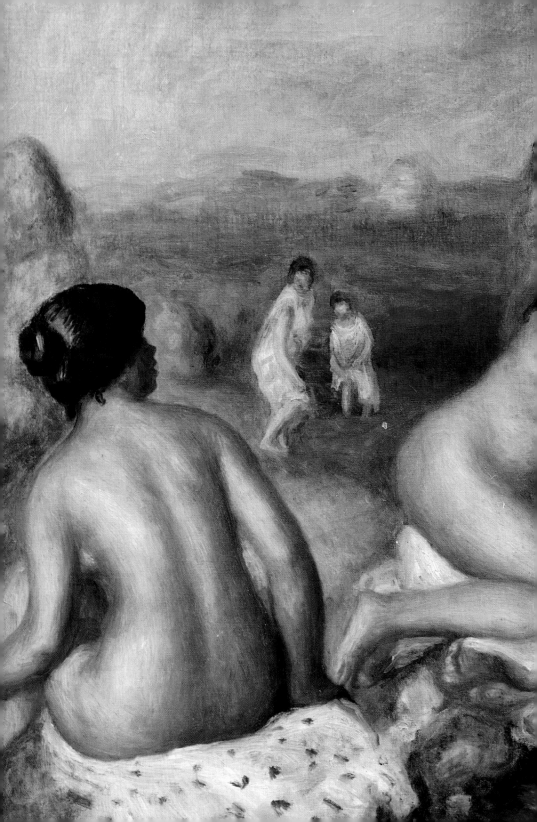

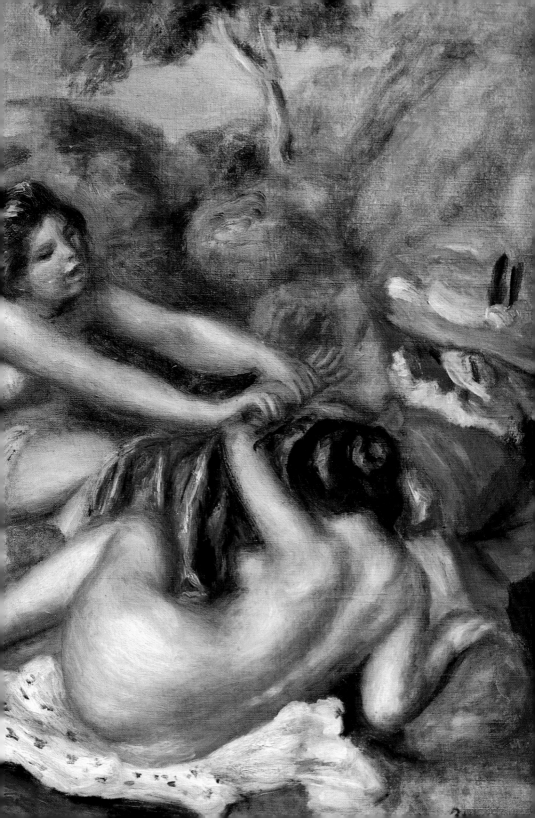

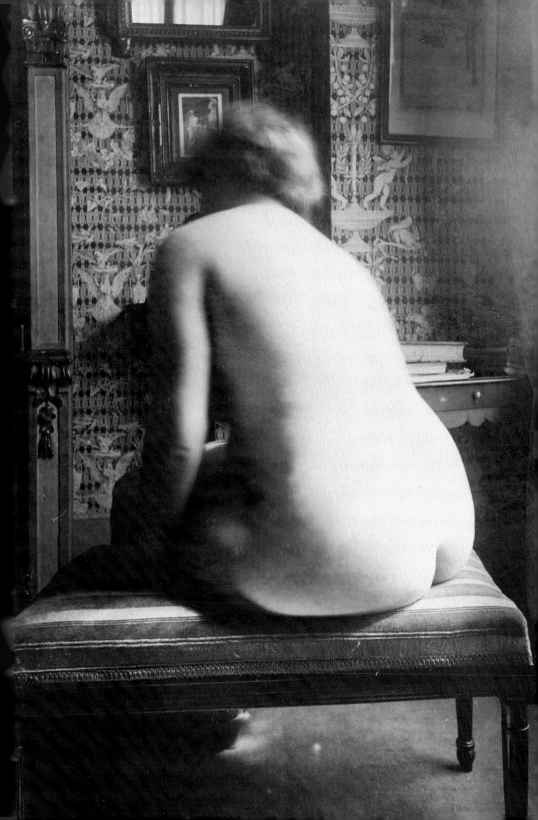

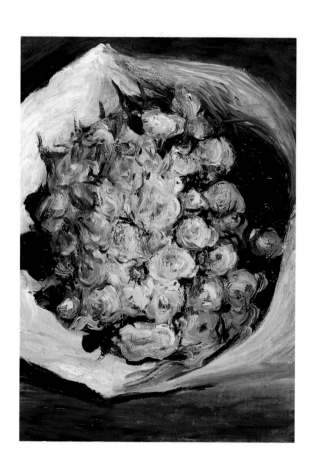

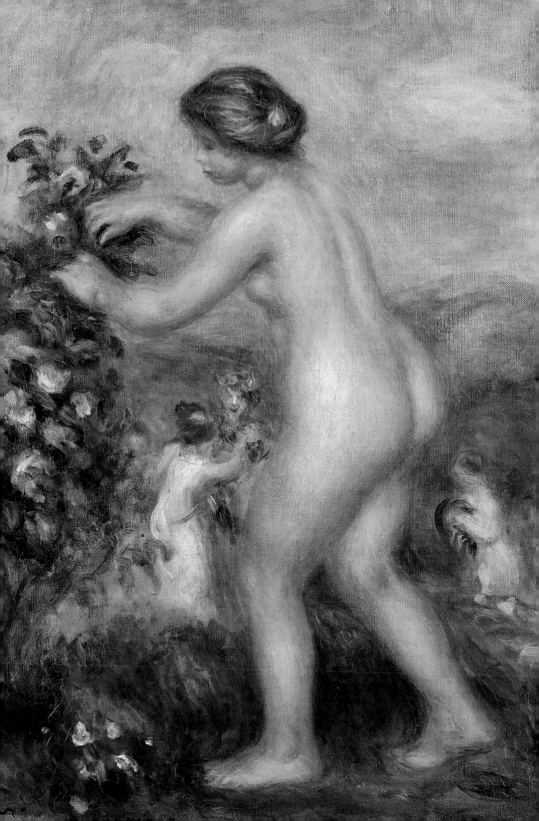

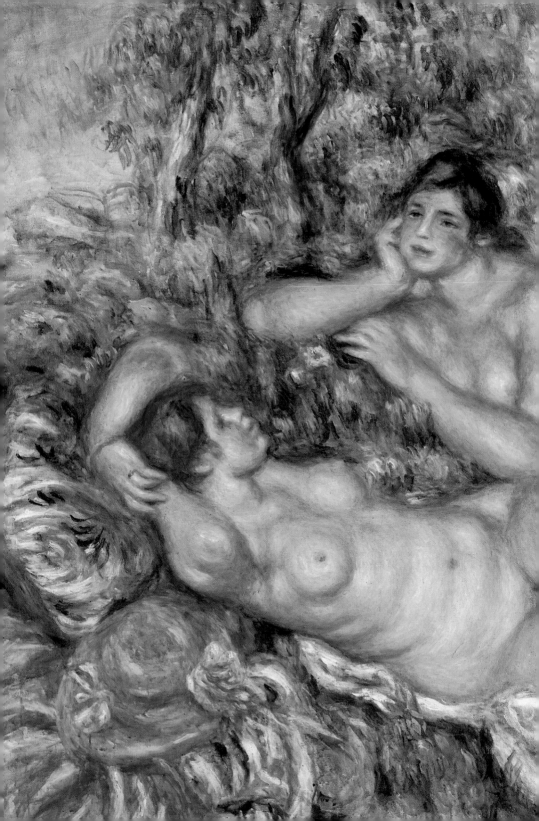

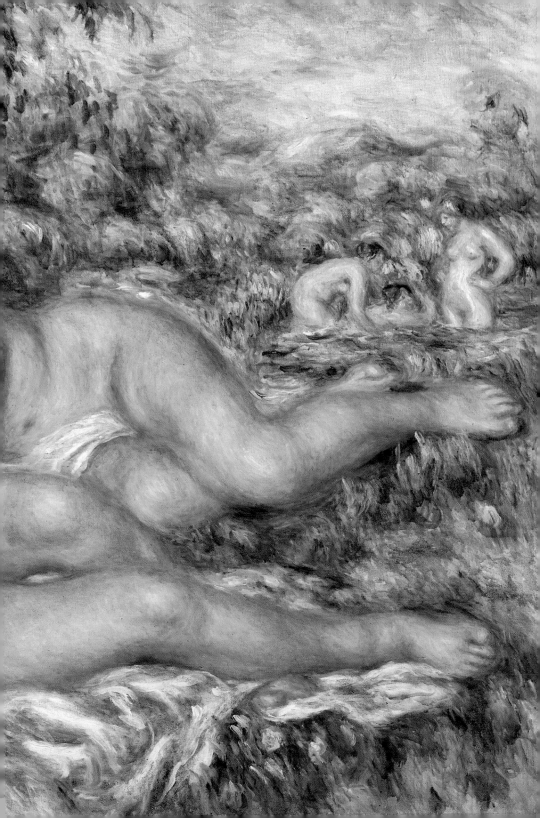

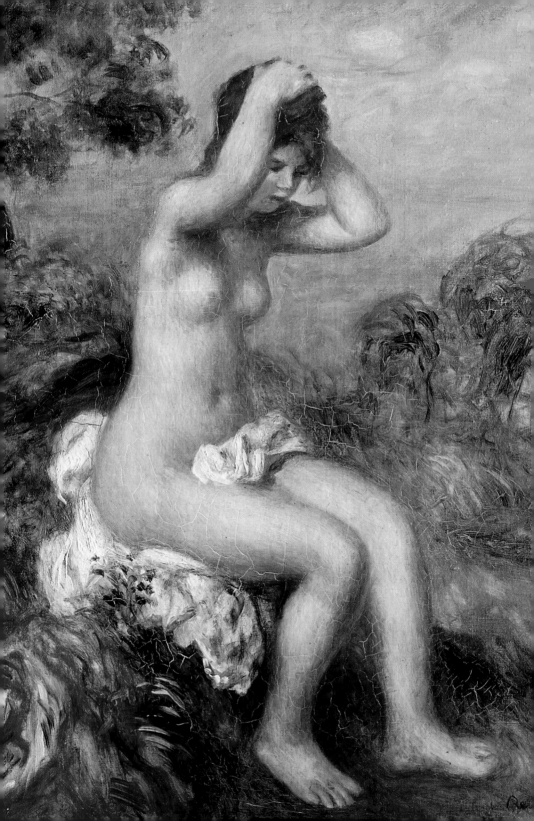

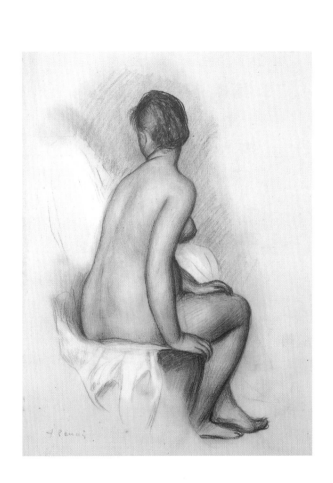

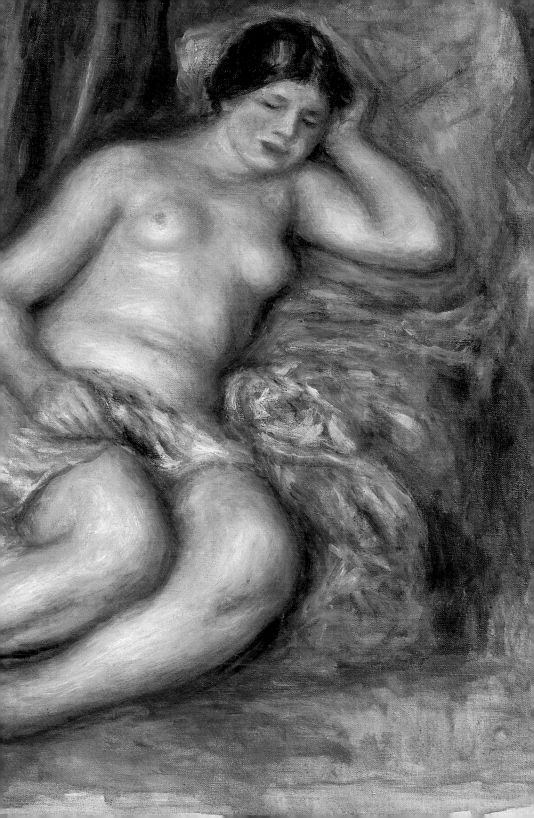

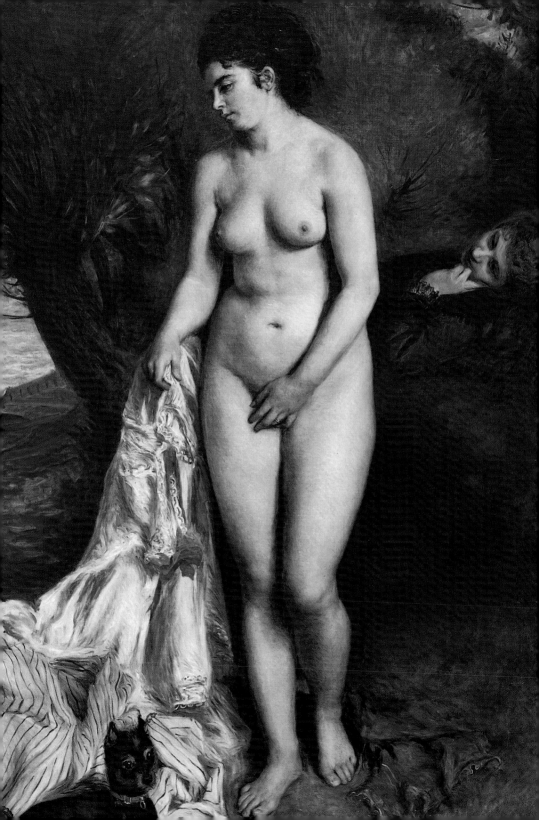

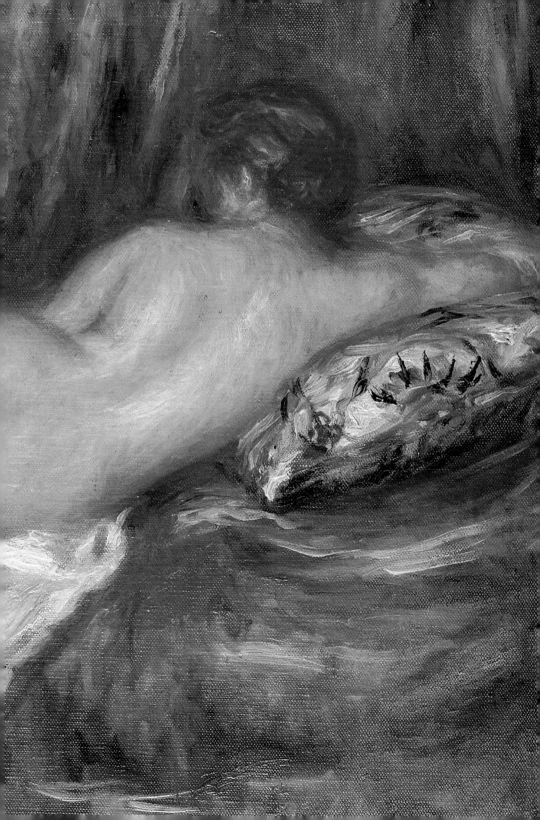

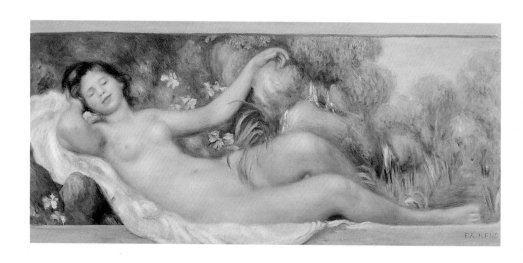

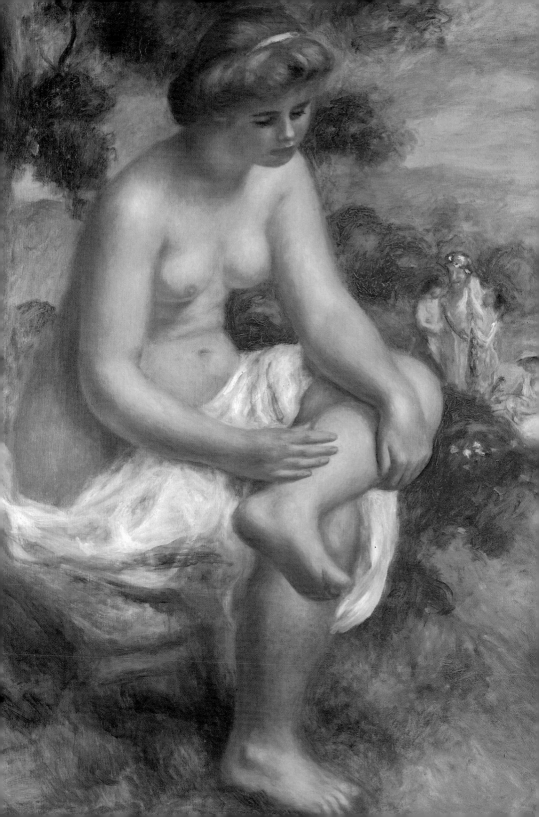

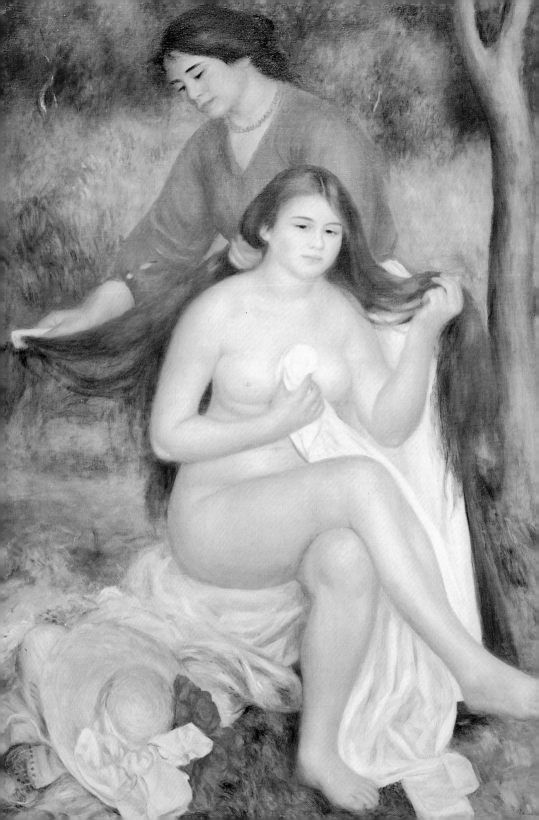

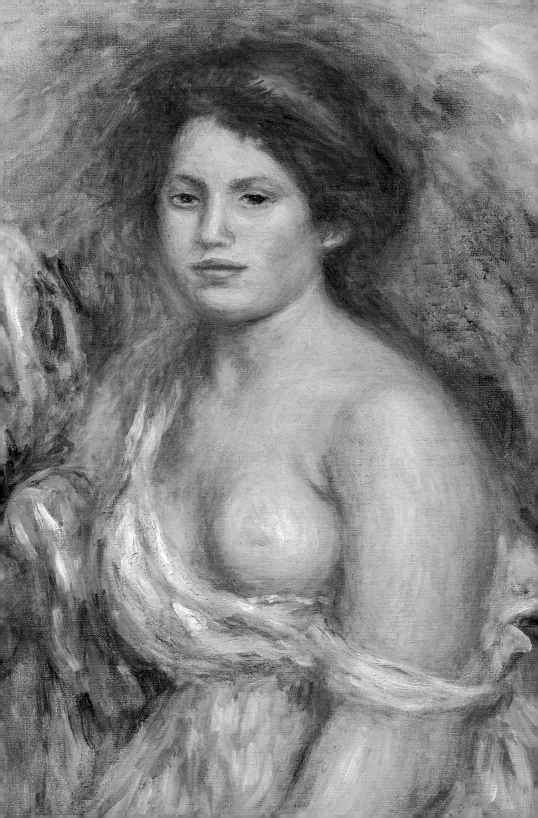

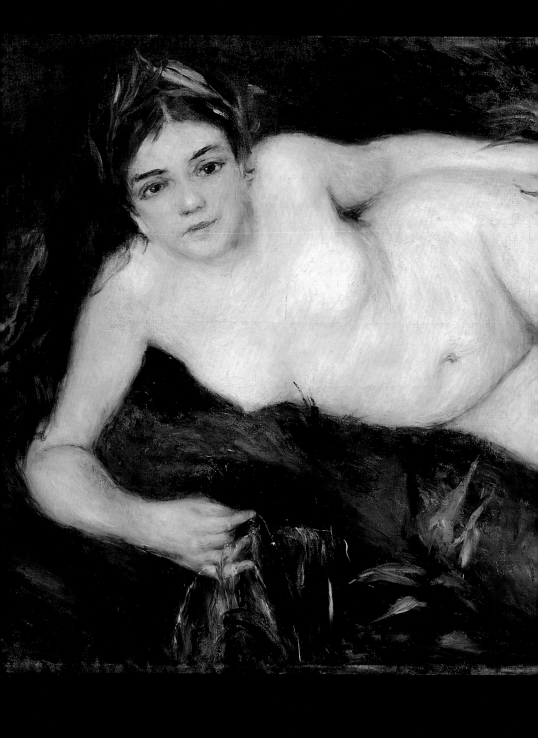

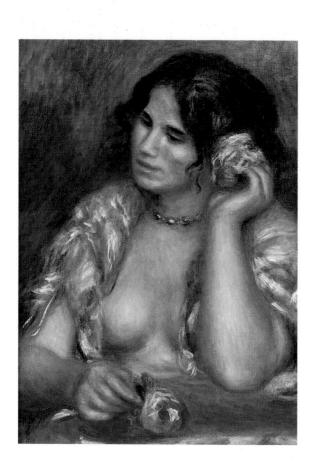

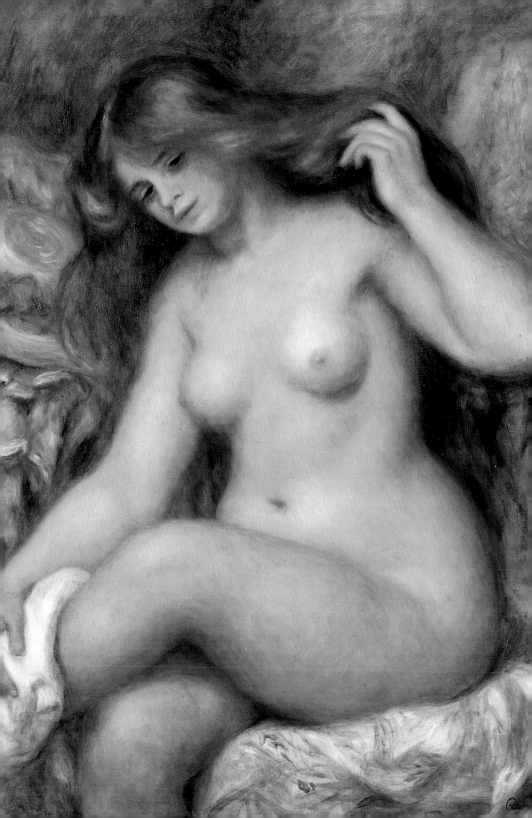

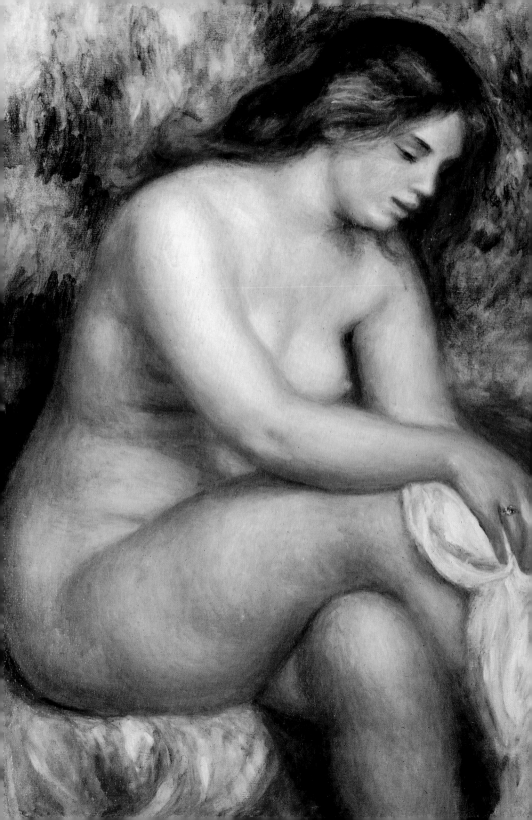

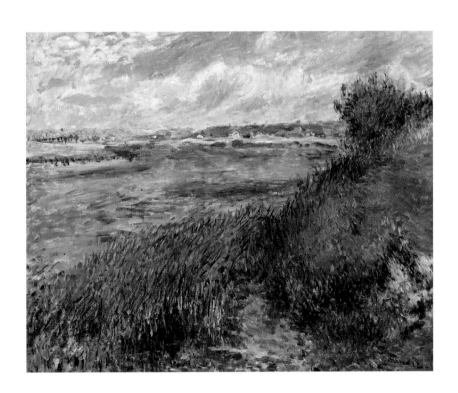

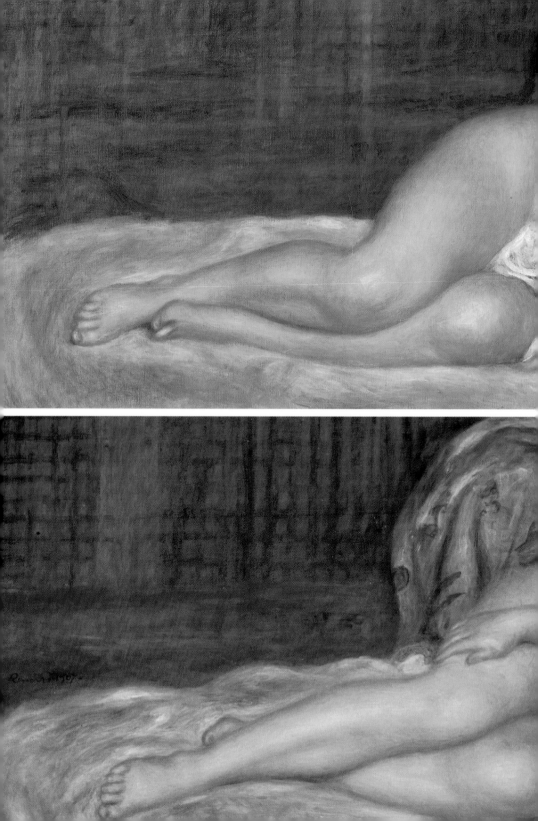

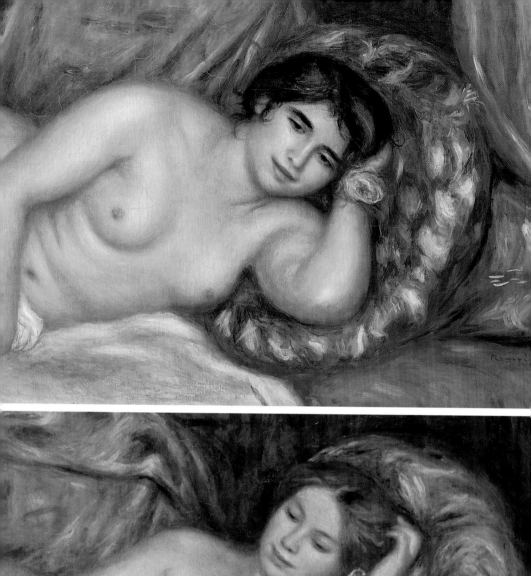
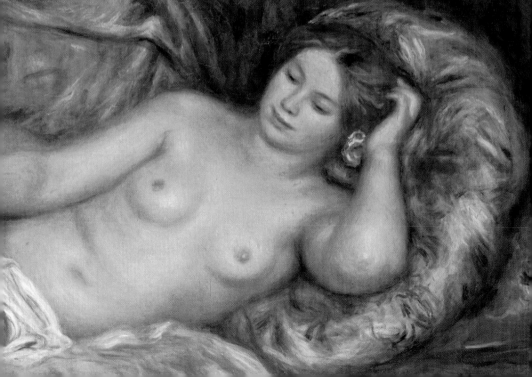

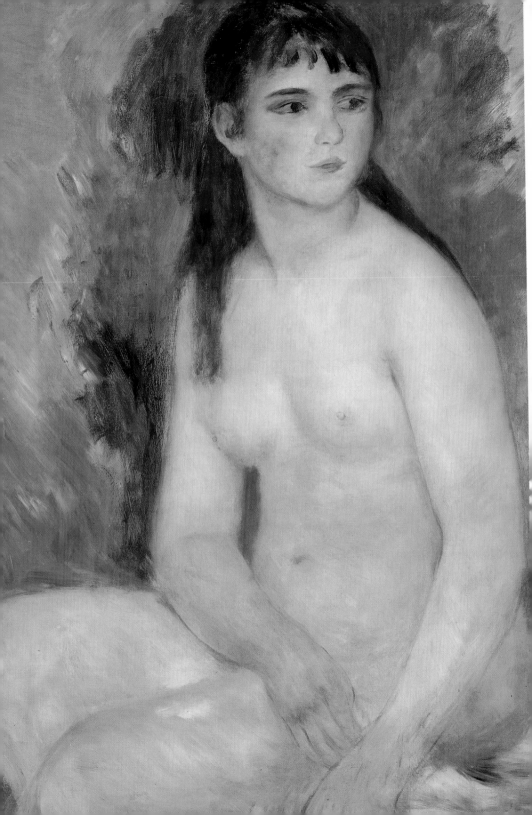

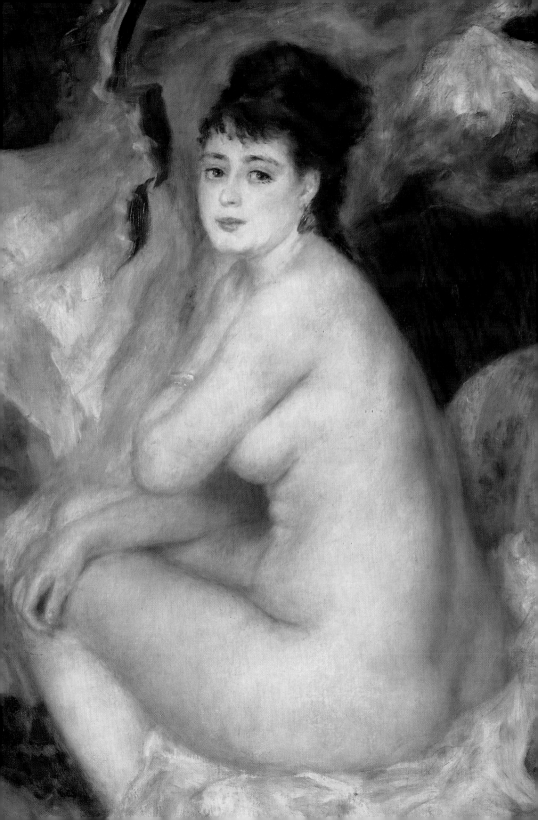

Renoir Nudes

Oil, 29.5 x 25 cm

The Rose, before 1872. Paris, Musée d'Orsay, gift of Ernest May. In this painting, the provocative expression of the sensual, bare-breasted young woman is softened by the delicacy of its workmanship. Paul Jamot believed the figure to be that of Fanny Robert (the Comtesse de Tessancourt), a beautiful woman whose amorous adventures were then well-known, but it is more likely Lise Tréhot, Renoir's favorite model in the early 1870s.

Oil, 65 x 54 cm

Bather, 1888. Winterthur, Oskar Reinhart Collection. This blonde bather drying herself with a towel had no difficulty in finding a buyer. It was purchased for 1500 francs on 10 December 1888 by a friend of Renoir's, the collector Robert de Bonnières, with Durand-Ruel acting as intermediary. In 1980 the painting reached £510.000 at a London auction.

Oil, 81 x 65 cm

Young Woman Asleep at the Water's Edge, 1897. Winterthur, Oskar Reinhart Collection. This young woman laid out before us seems to have drifted off into a dream filled with voluptuous pleasure. Rarely was Renoir as frank in the innocent expression of sensuality or the exaltation of female beauty.

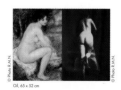

Oil, 65 x 52 cm

Nude in a Landscape, 1883. Paris, Musée de l'Orangerie, Collection Walter-Guillaume. This three-quarter-face pose presents an ample, graceful vision of a female body, stressing the movement of the back and the fulness of the body.
Nude Woman from the Back. Photograph by F. R. Carabin. Paris, Musée d'Orsay. Like many artists of the period, the sculptor Carabin used photographs in his work, whereas Renoir could find inspiration only in the presence of the live model.

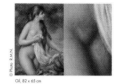

Oil, 82 x 65 cm

Bather with Long Hair, c. 1895. Paris, Musée de l'Orangerie. Collection Walter-Guillaume. Renoir here glorifies the fiery color of the hair and the golden body of this chaste Susanna through a contrast with the red, blue, and green hues of the landscape. The flesh is worked up by tiny brush strokes which serve to model the forms. Pearly white highlights accentuate the luminous radiance of a body reminiscent of the palette of Titian.

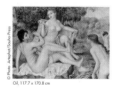

Oil, 117.7 x 170.8 cm

The Bathers (Les Grandes Baigneuses), 1884-87. Philadelphia Museum of Art, Pennsylvania, Mr. and Mrs. Carroll S. Tyson Jr. Collection. The bathers' bodies are treated with precision and delicacy in the manner of Ingres: their postures and gestures are filled with an expressivity bordering on the Mannerist. This scene can be read on a number of levels, suggesting the pleasures to be had near water and at play, and also reflecting on the beauty of the female body and on womanly vanity.

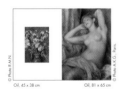

Oil, 45 x 38 cm Oil, 81 x 65 cm

Bouquet of Tulips, 1905. Paris, Musée de l'Orangerie, Collection Walter-Guillaume. Bouquets awash with color and light, the flower and nude paintings of the artist's last years comprise a fulsome peaen to nature, beauty, and life.

Reclining Nude,1897. Winterthur, Oskar Reinhart Collection. Rarely was Renoir as frank in the innocent expression of sensuality and his exaltation of female beauty as in this Oriental scene evoking Delacroix's Odalisques.

Oil, 54 x 65.5 cm Oil, 81 x 65 cm

The Railway Bridge at Chatou or **The Pink Chestnut Trees (detail), 1881.** Paris, Musée d'Orsay, Caillebotte Bequest. Juxtaposing little daubs of brightly colored paint, Renoir captures the fleeting effects of light on water and in the foliage.

Torso of a Woman in the Sun (study), 1875. Paris, Musée d'Orsay, Caillebotte bequest. A muted variation on nuances of pink and green enlivened with highlights on the very pale skin.

Oil, 35.5 x 27cm Oil, 93 x 73 cm

Musk Roses, c. 1890. Paris, Musée d'Orsay, Paul Jamot Bequest. Having produced many paintings of wild flowers, Renoir became smitten with more sophisticated types of flower. Roses play an important role in his canvases, as he himself explained: "These form part of the same research on flesh tones as in my nudes." And indeed these roses do evoke the beauty, freshness, and scent of a woman.

After the Bath, 1876. Vienna, Kunsthistorisches Museum, Neue Galerie.

Oil, 54 x 65 cm

Three Bathers, 1897. Cleveland Museum of Art. A young girl is holding a little crab which almost touches the face of one of her companions who cannot defend herself as her arm is held fast. This playful, slightly aggressive atmosphere – absent from the earlier version of the painting – is most unusual in Renoir's works. It jars with the idyllic landscape, perhaps an inlet in Brittany, which serves as the setting for the scene.

Seated Nude Seen from the Back. Photograph by Eugène Atget. Paris, Musée d'Orsay. In the 19th century, painting and photography were involved in a close and sometimes competitive relationship. In this superb nude plastic qualities can be detected close to those in certain works by Renoir, but in fact it is neither a photograph of one of the artist's models nor one used in a composition.

Oil, 40 x 50 cm Oil, 46 x 36 cm

Bouquet (detail), 1880. Paris, Musée de l'Orangerie, Collection Walter-Guillaume. This bouquet of small, delicate-hued roses left on the crimson velvet of a box at the theatre seems to allude to a tribute left by an admirer.

Ode to the Flowers, 1903-1909. Paris, Musée d'Orsay, on loan to the Musée des Beaux-Arts, Limoges. The naked young woman in the foreground is picking flowers which her companions are weaving into a crown to decorate the herm of a god.

The Bathers, c. 1918-1919. Paris, Musée d'Orsay, bequest of the artist's son. This large group of bathers represents the final outcome of Renoir's work on the female nude. The landscape laid in by little touches of vibrant color resembles a tapestry lying around the women's bodies. Renoir, far from translating a real scene on to the canvas, presents here an expansive and vigorous imaginary picture of the bathers, occasionally at the cost of a lifelike rendering of anatomy.

Bather Arranging her Hair, 1896. Winterthur, Oskar Reinhart Collection. The young woman is arranging her chignon. The artist has left ample space for the landscape which opens up in the distance on to the infinity of the sea.
Nude Bather Seated, c. 1885-1890. Sanguine with white highlights on paper. Private collection. Renoir liked above all to use red chalk for preparatory studies as it is a warm-colored medium close to that of flesh itself.

Sleeping Odalisque, c. 1915-1917. Paris, Musée d'Orsay, gift of Dr. and Madame Albert Charpentier. Renoir normally preferred his models seated in three-quarter-face or else reclining in profile. Here, the languorous body, full-face in a daring and quite exceptional foreshortening, and curled up slightly in her sleep, is supported on the right by a mountain of cushions and on the left by a curtain draped before a bay with columns.

Bather with a Dog, 1870. Sao Paulo, Museu de Arte of Sao Paulo, Assis Chateaubriand. This large-scale bather, exhibited for the first time at the Salon of 1870 is a dual homage to Courbet's realism and Manet's modernity. Like Courbet, Renoir presents us with an unidealized, life-size woman, while the background landscape where a reclining woman appears in inaccurate perspective seems to have no connection with the main subject of the canvas.

Reclining Nude seen from the Back or **Rest after the Bath, c. 1909**. Paris, Musée d'Orsay, gift of Dr. and Madame Albert Charpentier. Renoir produced several almost identical small-format compositions showing a reclining nude on a sofa from the rear. The model's position stresses the graceful curve of the back and the roundness of the hips, while the draperies and cushions evoke the muffled atmosphere of an alcove.

Eurydice, c. 1883. Paris, Musée d'Orsay, allocated to the Musée Picasso. This painting is often interpreted as a portrayal of Eurydice, the wife of Orpheus, being pursued by Aristea who had fallen in love with her. Bitten by a snake, she dies of its effects.
The Source, c. 1895-1897. Merion, Pennsylvania, Barnes Foundation. Provocative yet still ingenuous, this young girl sleeping is the embodiment of a pure spring of life and pleasure. Her elongated body is close to those of the Mannerists.

The Toilette, 1900. Merion, Pennsylvania, Barnes Foundation. By picturing outside, Renoir breathes new life into a classic theme in western painting, the toilette. The modest-looking brown-haired servant in the background of the composition underscores the striking beauty of the nude with long blonde hair in the foreground.
Half-length Portrait of a Model, 1916. Paris, Musée Picasso. This strong-limbed, haughty-looking nude once belonged to Picasso.

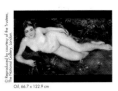

A Nymph by the Stream, c. 1871-1872. London, The Trustees of the National Gallery. This youthful nude reclining on the grass represents the allegory of a spring. Unlike Ingres, Renoir does not attempt to idealize his model, but, following Courbet, places the accent on the reality of the flesh, her skin dappled with green shadows in keeping with the surrounding nature. The straightforward manner in which the nymph looks at us adds a further note of realism to the scene.

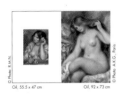

Gabrielle with a Rose, 1911. Paris, Musée d'Orsay, gift of Philippe Gangnat.
Bather, c. 1903. Vienna, Kunsthistorisches Museum, Neue Galerie. The clothes next to the nude give a definite modern look to the scene. Renoir jettisoned this arrangement in his numerous later variants of a nude drying her leg.

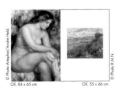

Bather Drying her Leg, c. 1910. Sao Paulo, Museu de Arte of Sao Paulo, Assis Chateaubriand. The nude carefully towels her leg, neither exhibiting, nor concealing her opulence from our gaze.
The Banks of the Seine at Champrosay, 1876. Paris, Musée d'Orsay, Caillebotte Bequest. This landscape on the banks of the Seine was composed entirely by juxtaposing little strokes of paint in a pure Impressionist style.

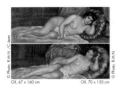

Reclining Nude, 1903. Paris, Musée de l'Orangerie, Collection Walter-Guillaume. With this nude of the sitter Gabrielle Renard, Renoir left off his suggestive style of the years 1890-1900 and returned to more classical facture harking back to Ingres.
Nude on Cushions, 1907. Paris, Musée d'Orsay, gift preserving a life interest of M. and Mrs. Robert Kahn-Scriber. In this last of three versions of this nude, the warm tone of the hair and the accessories give the painting a Venetian feel.

Nude, 1880. Paris, Musée Rodin (P/334). The rather wild and impenetrable facial expression of the young girl, together with the firm, yet soft beauty of her body fascinated Renoir who was to keep this canvas all his life.
Seated Nude, Anna, 1876. Moscow, Pushkin Museum. The bold way the model looks at the viewer is countered by the arm moving to cover the bust, a tension often met with in Renoir's nudes.